Color Your Own Pinup

A Saucy Coloring Book

By

Dan Morrill

All photographs by Dan Morrill/Studio5Graphics

Thank you to every model in the book for helping me learn a lot, have a lot of fun, and otherwise explore what you can do with the world, how we look at it, and of course, helping me come up with a Saucy Coloring Book.

Big props go out to Chris and Jessica, Kristy, Darren, Steve, and everyone else who said - just do it.

ISBN-13: 978-1492197423

Copyright Dan Morrill Studio5Graphics 2013

Studio5graphics.com

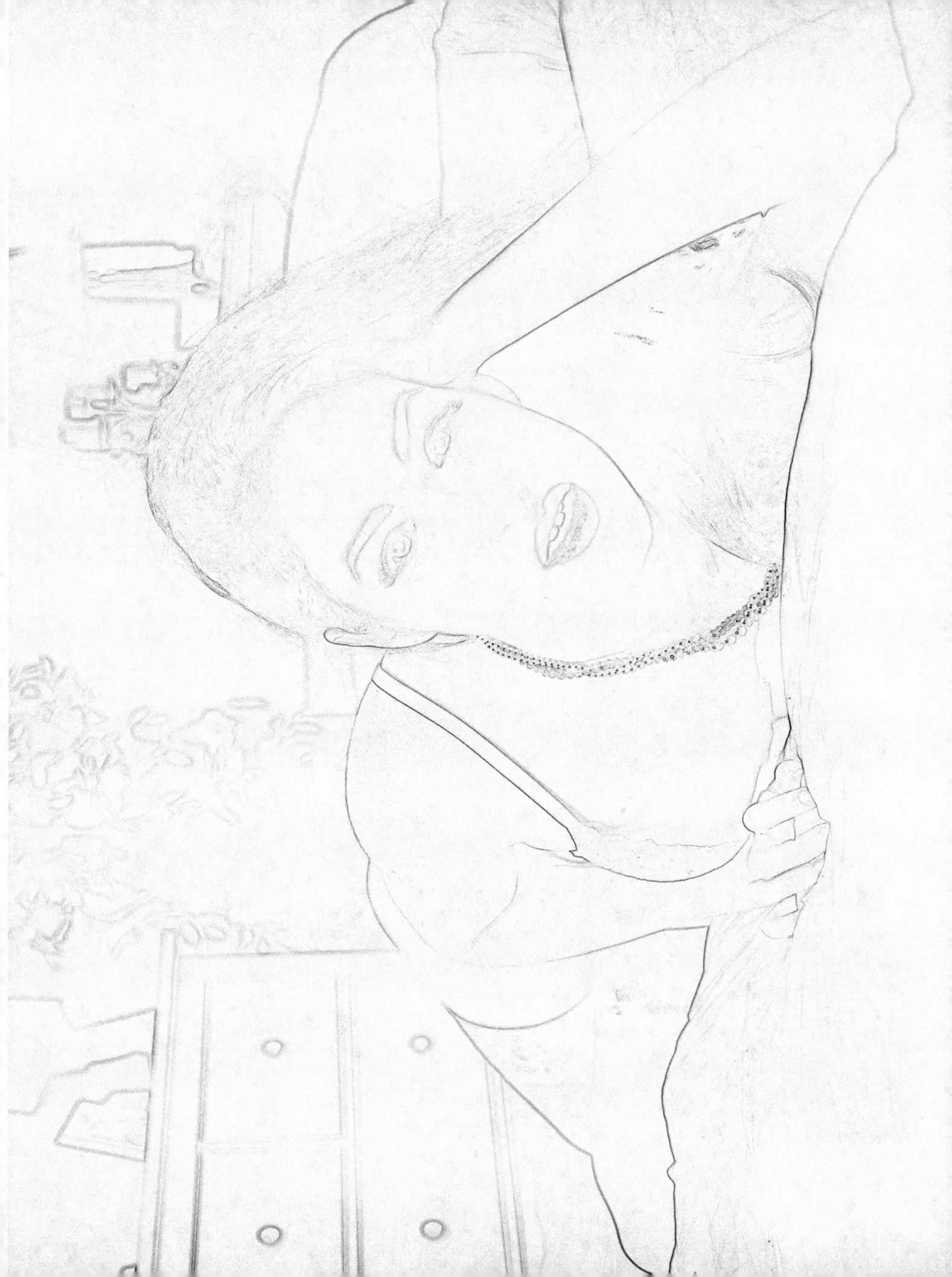

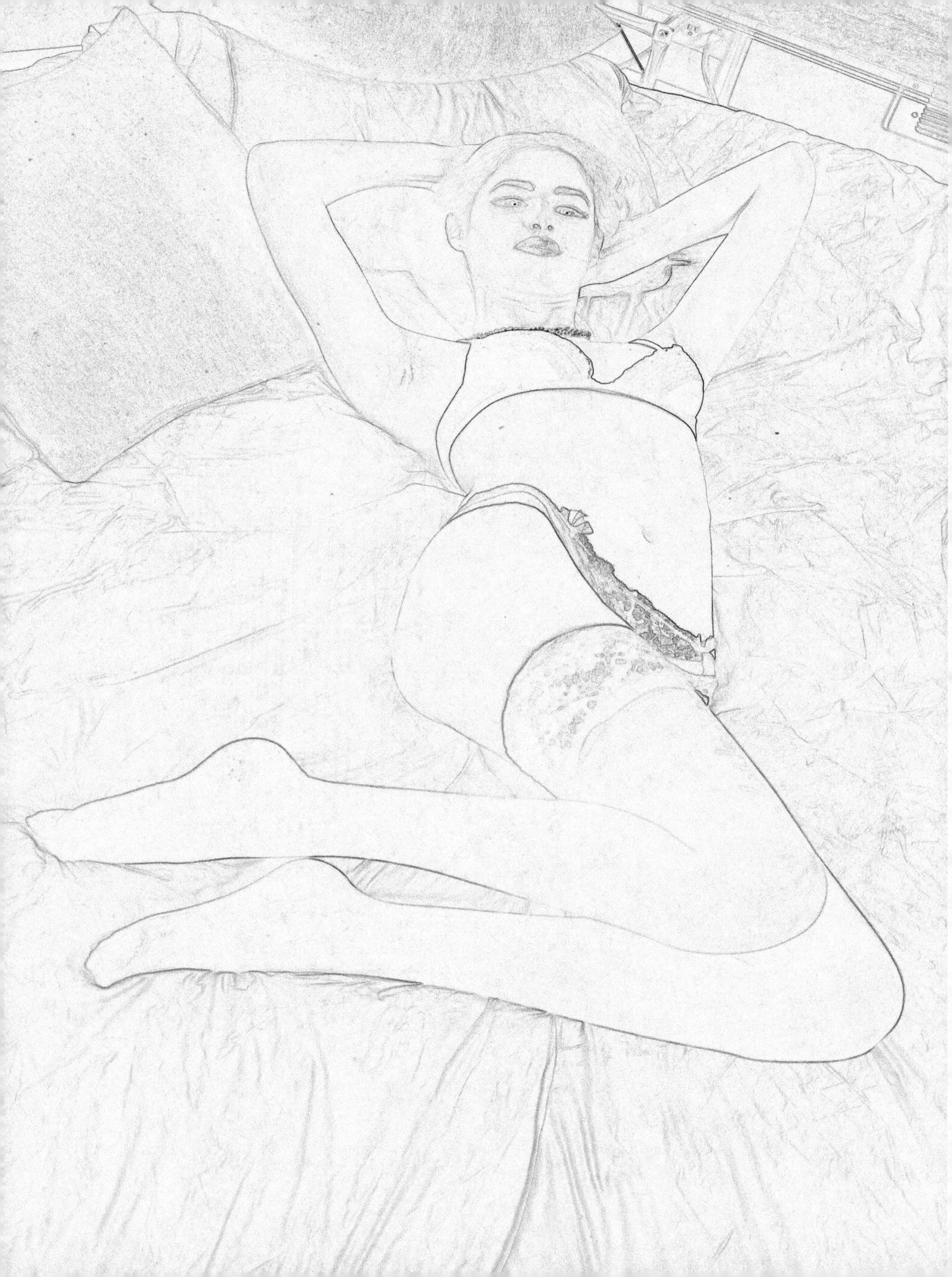

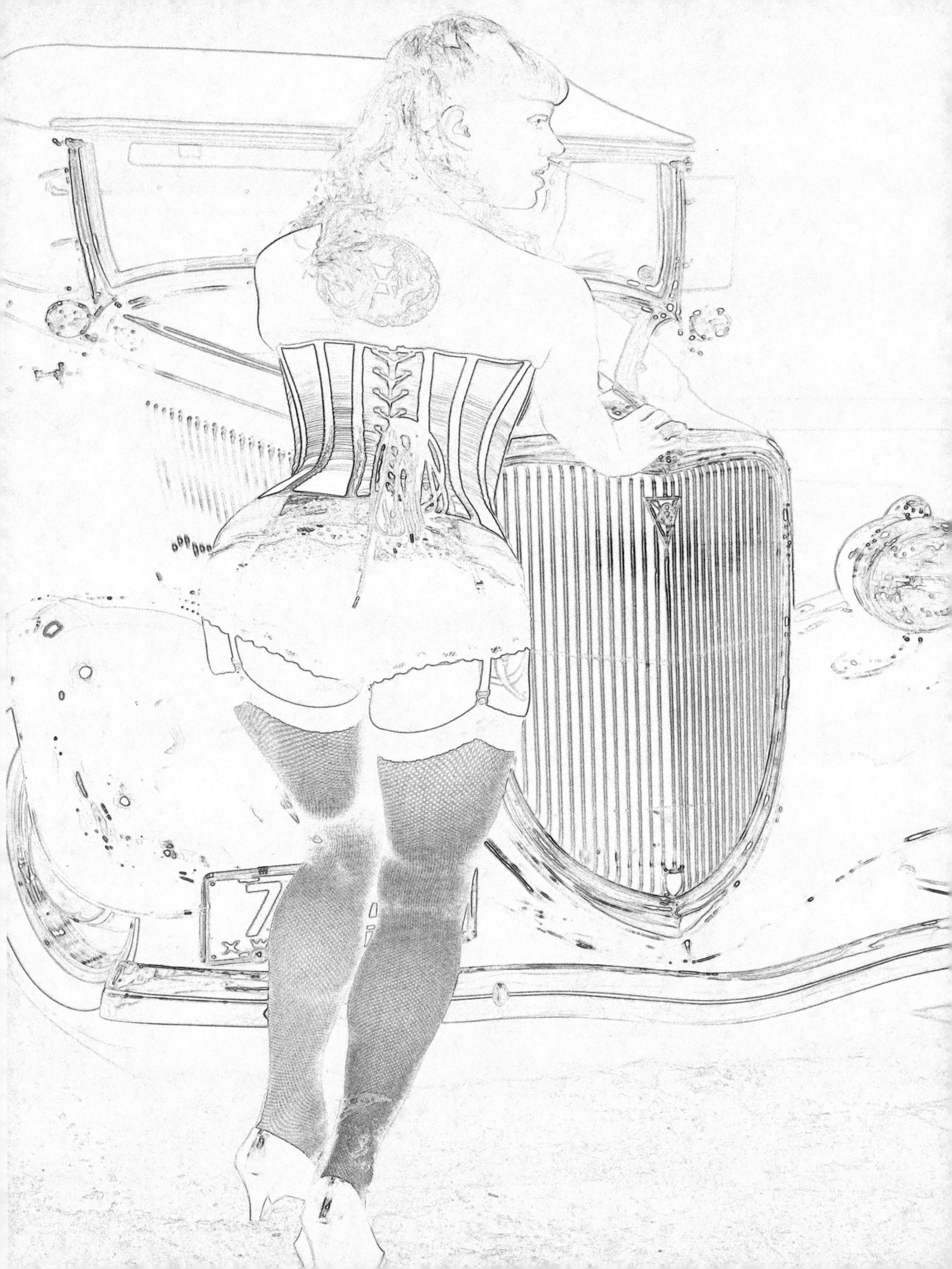

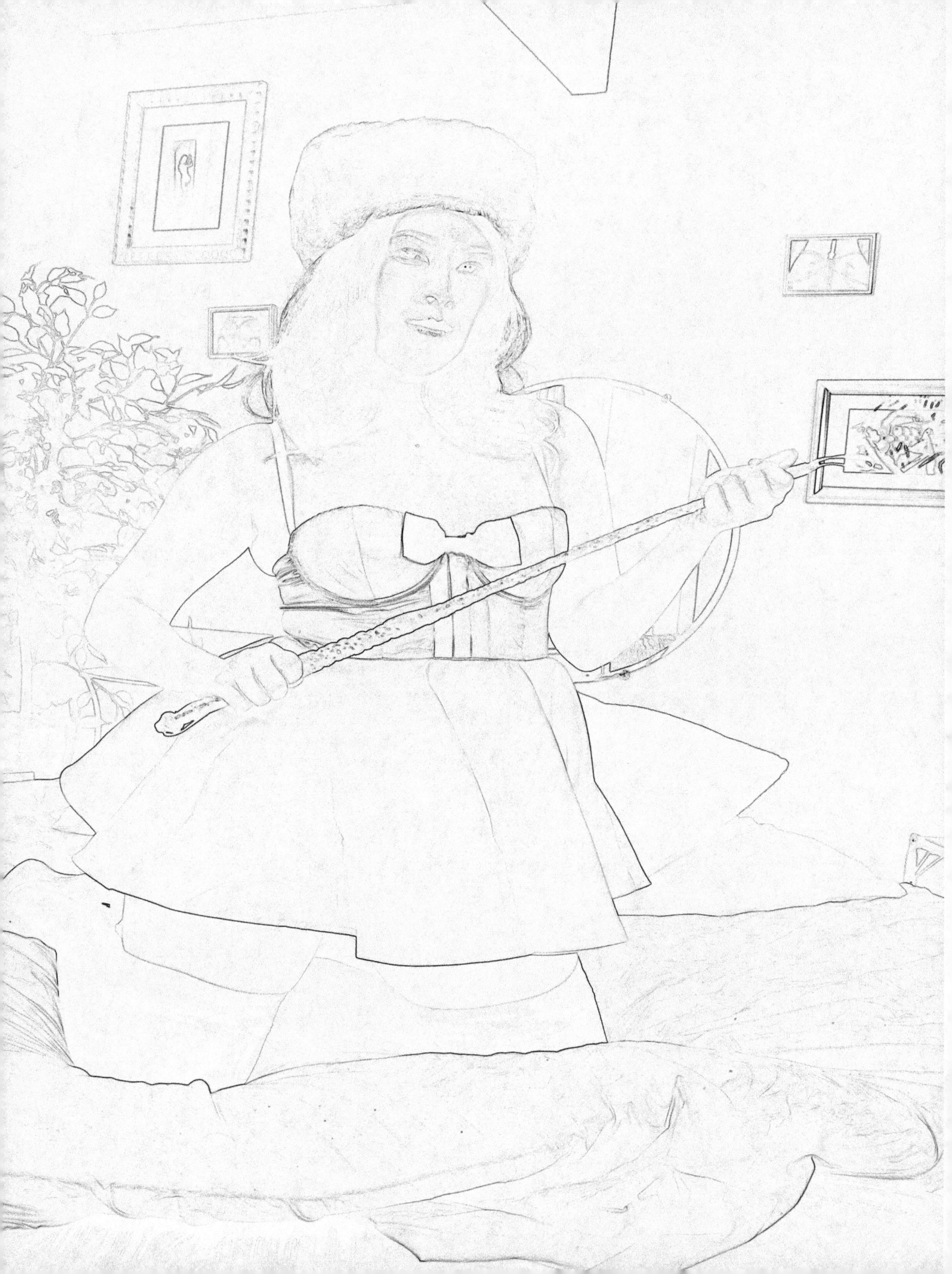

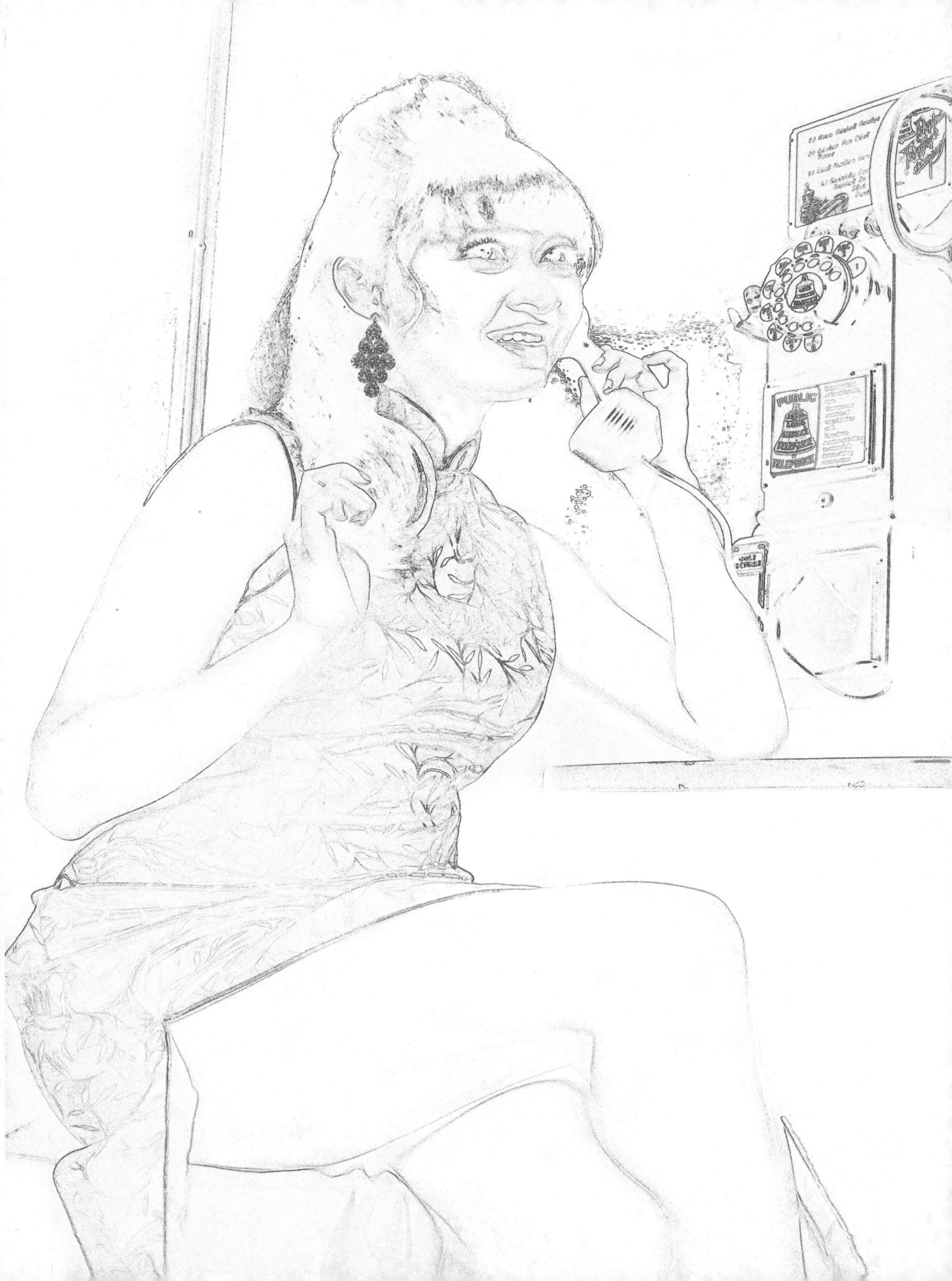

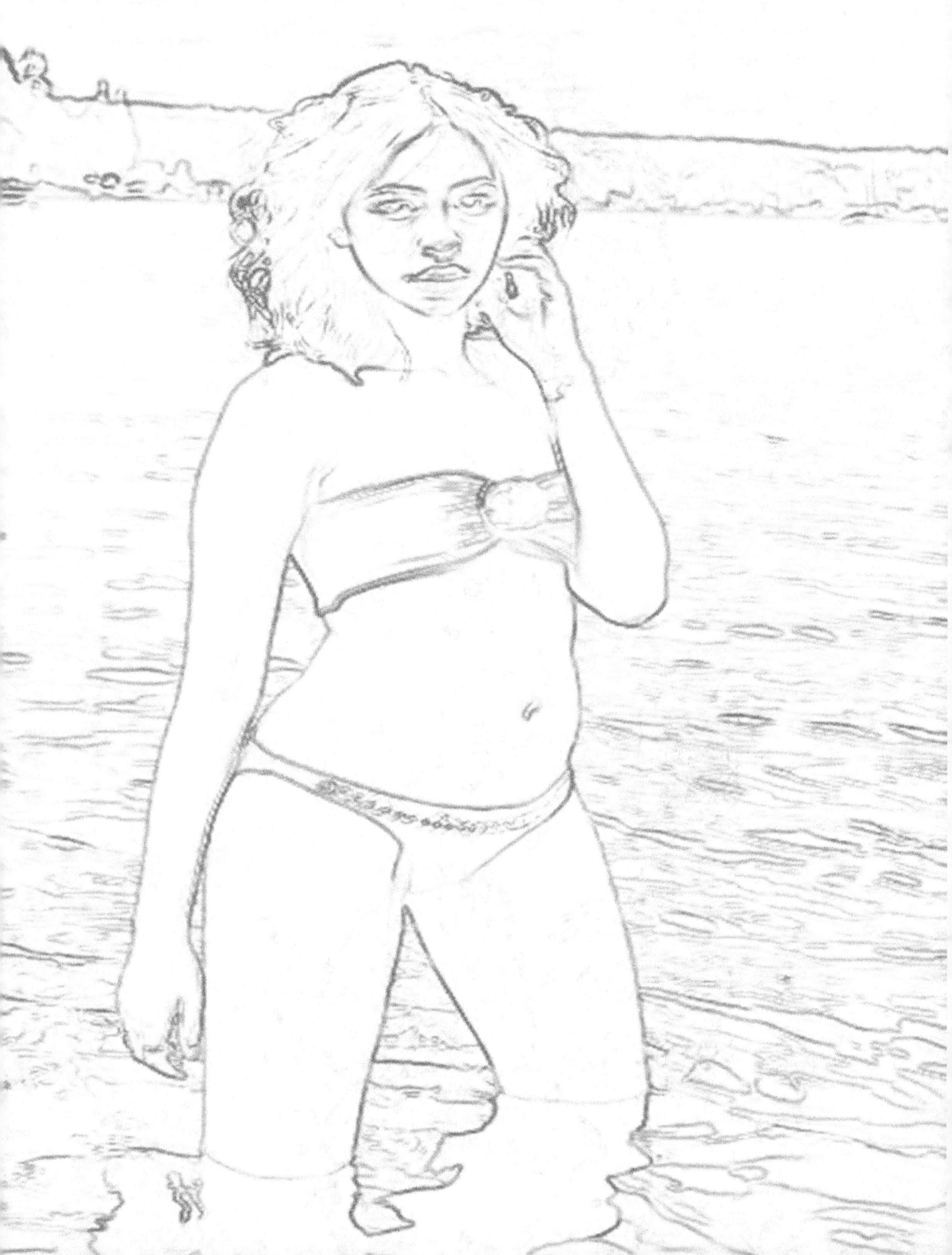

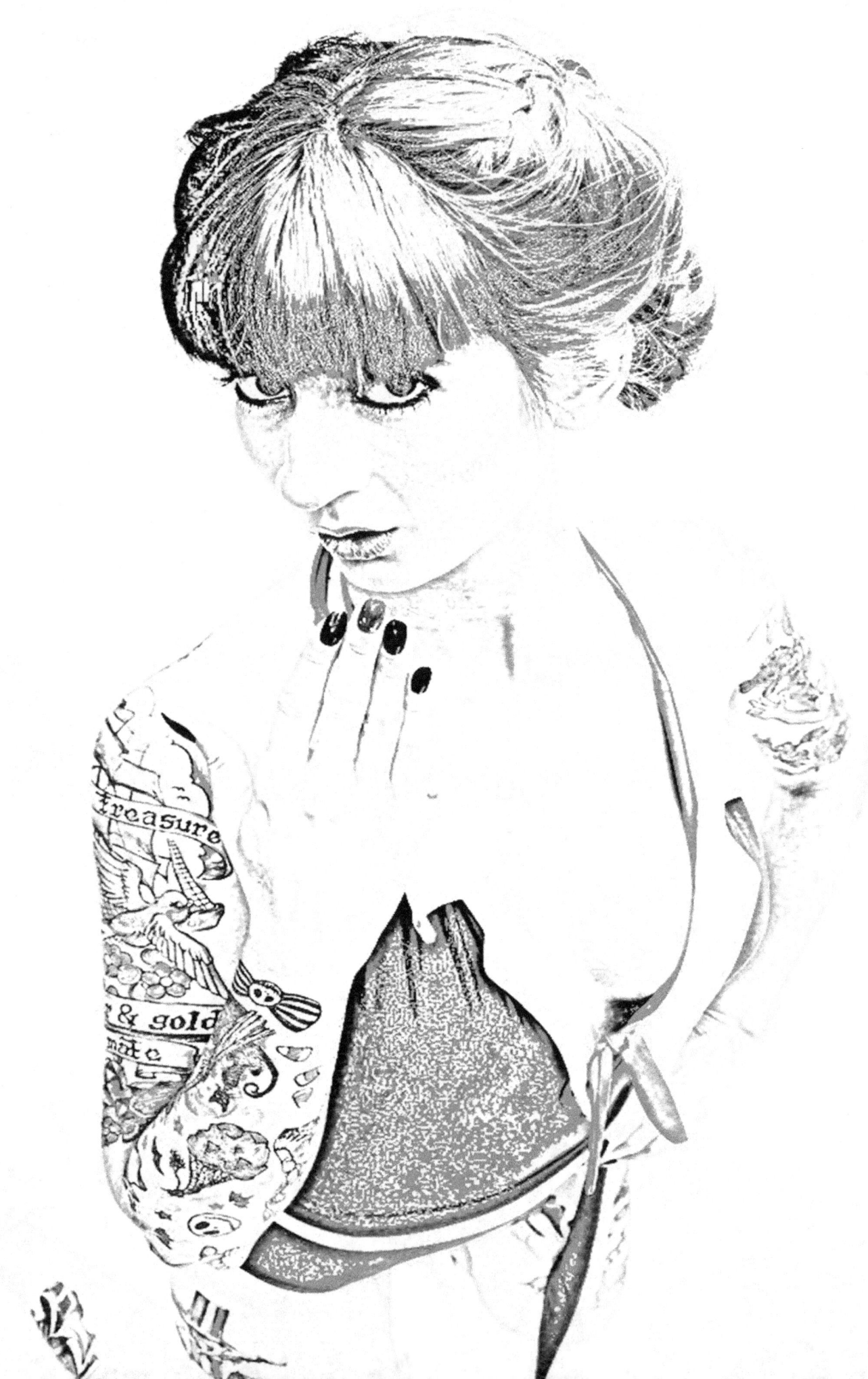

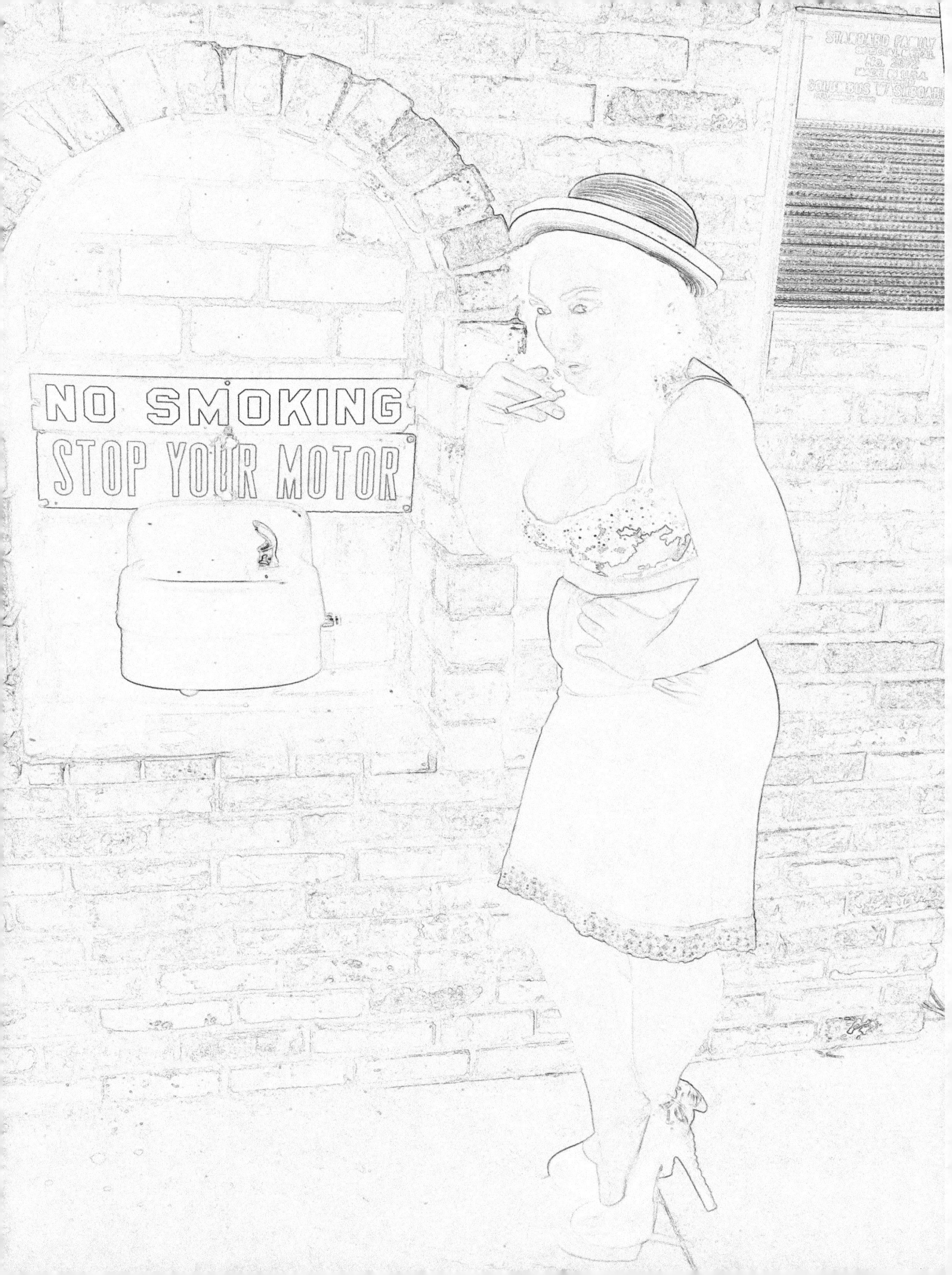

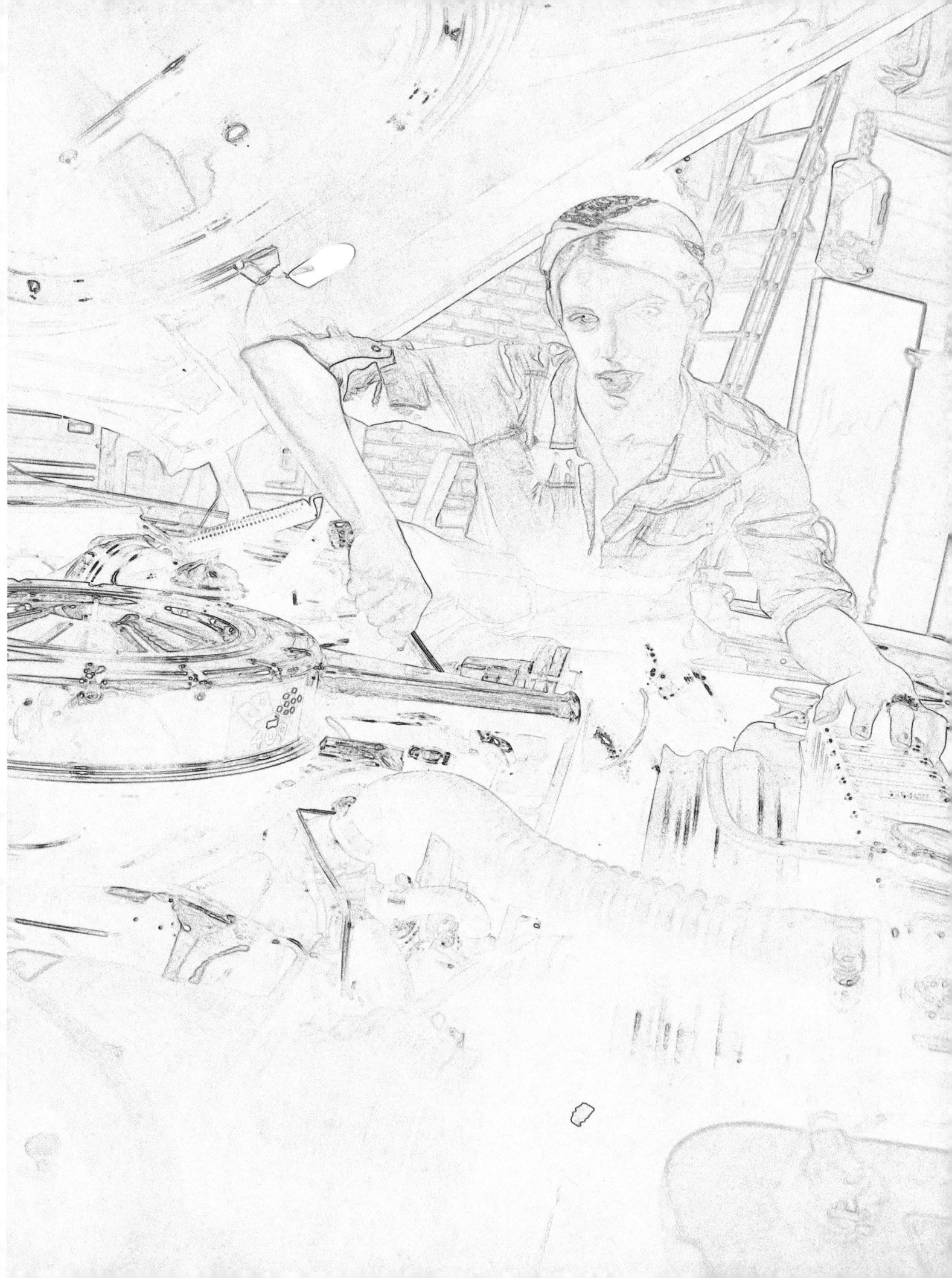

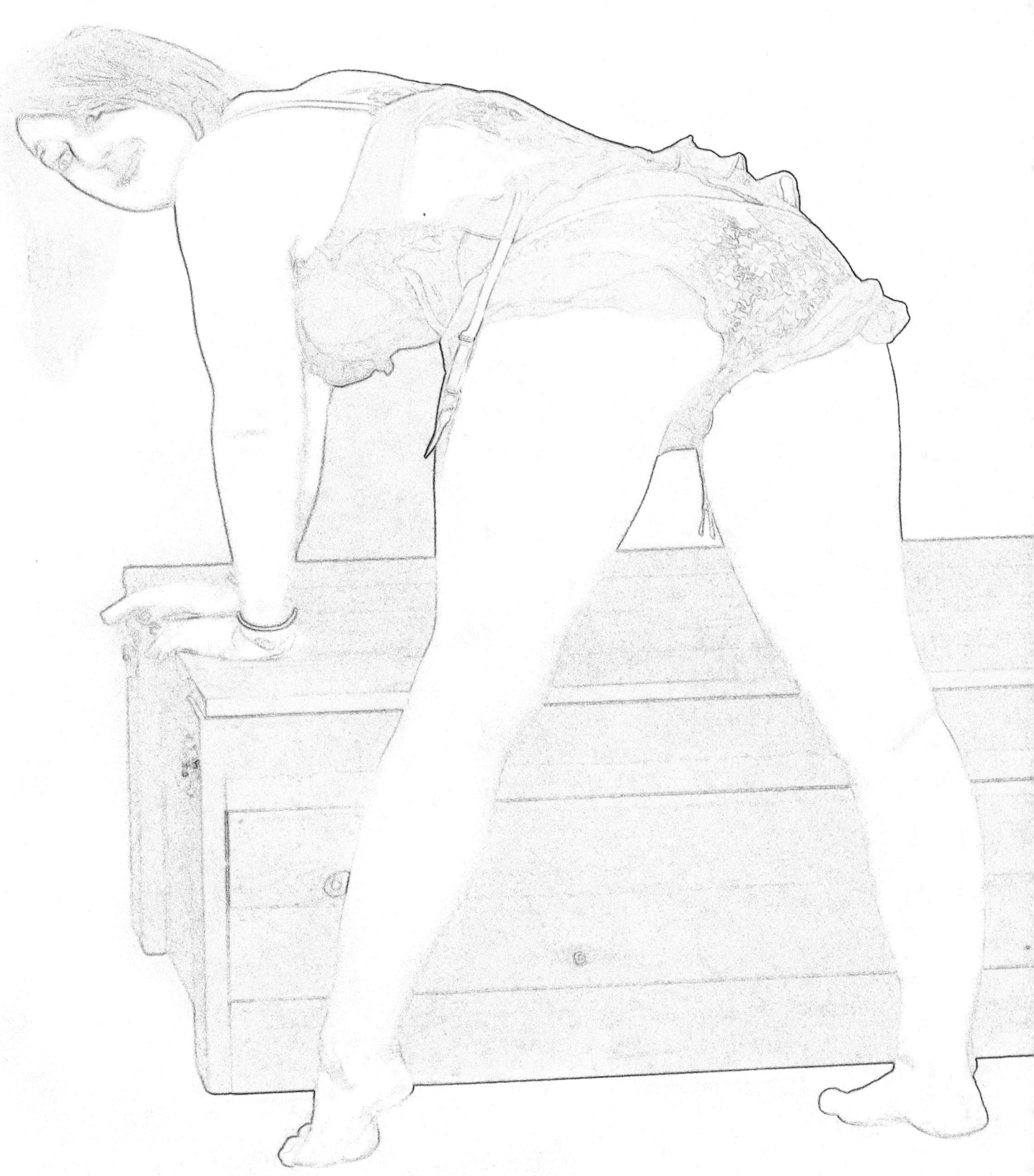

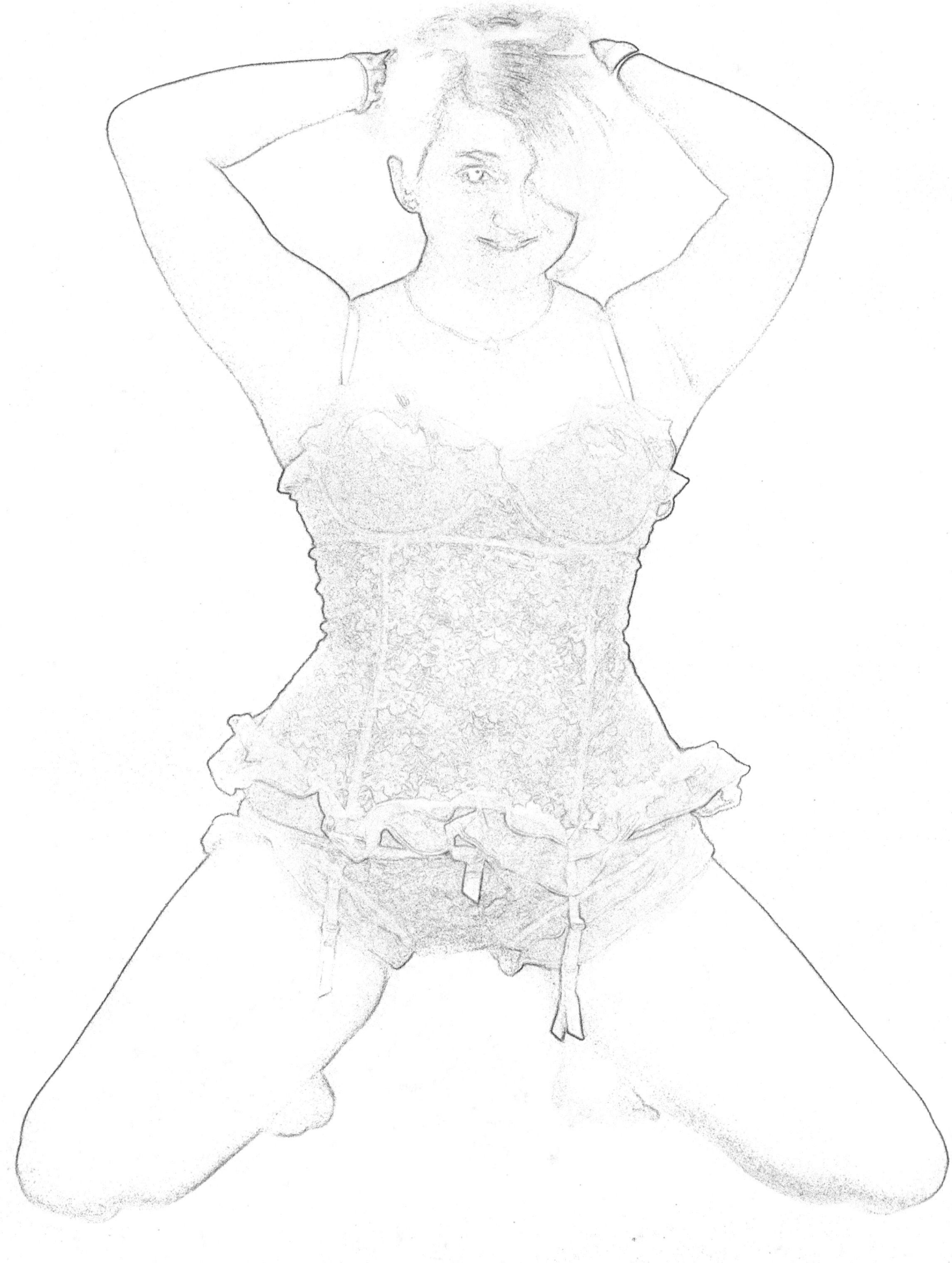

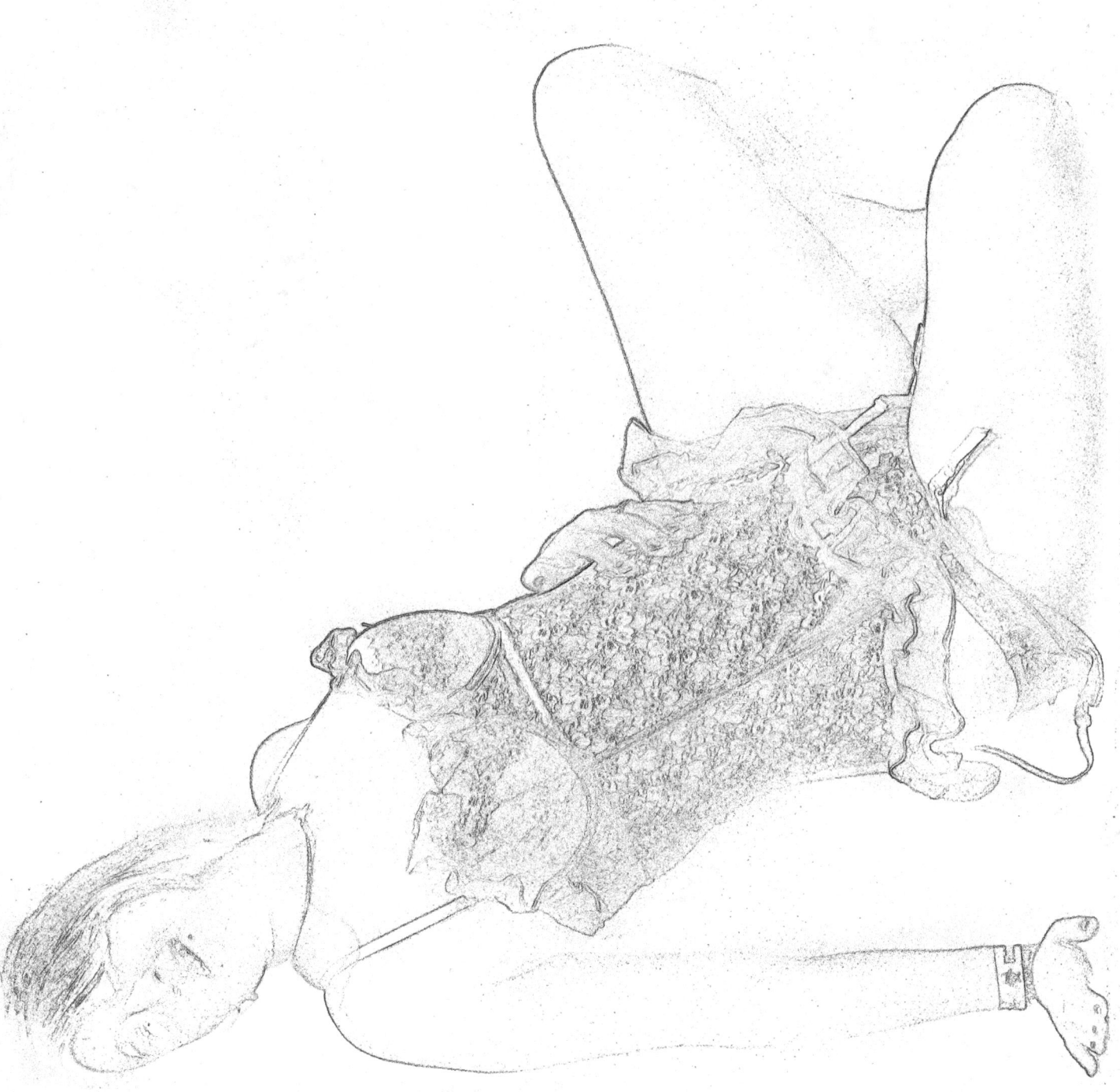

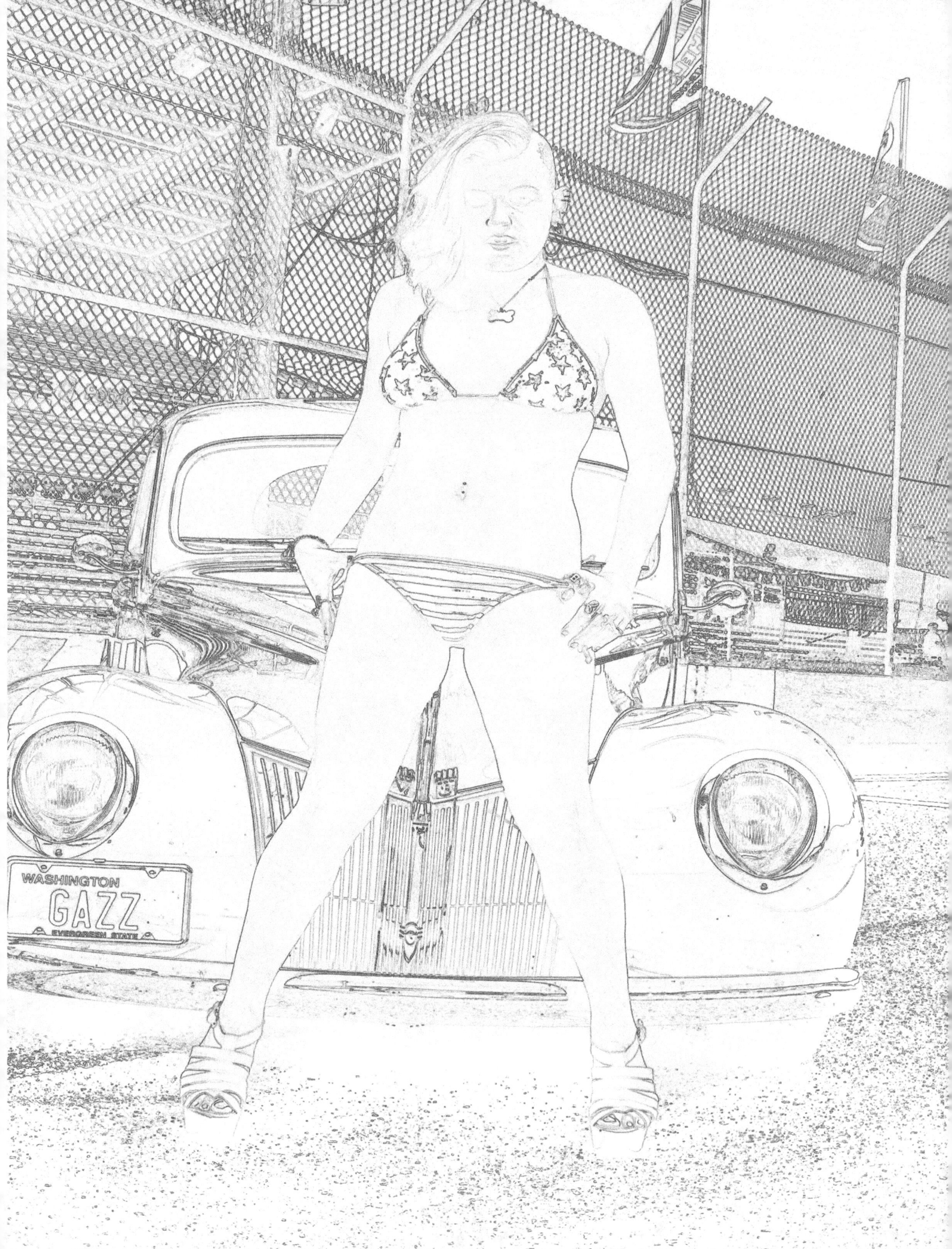

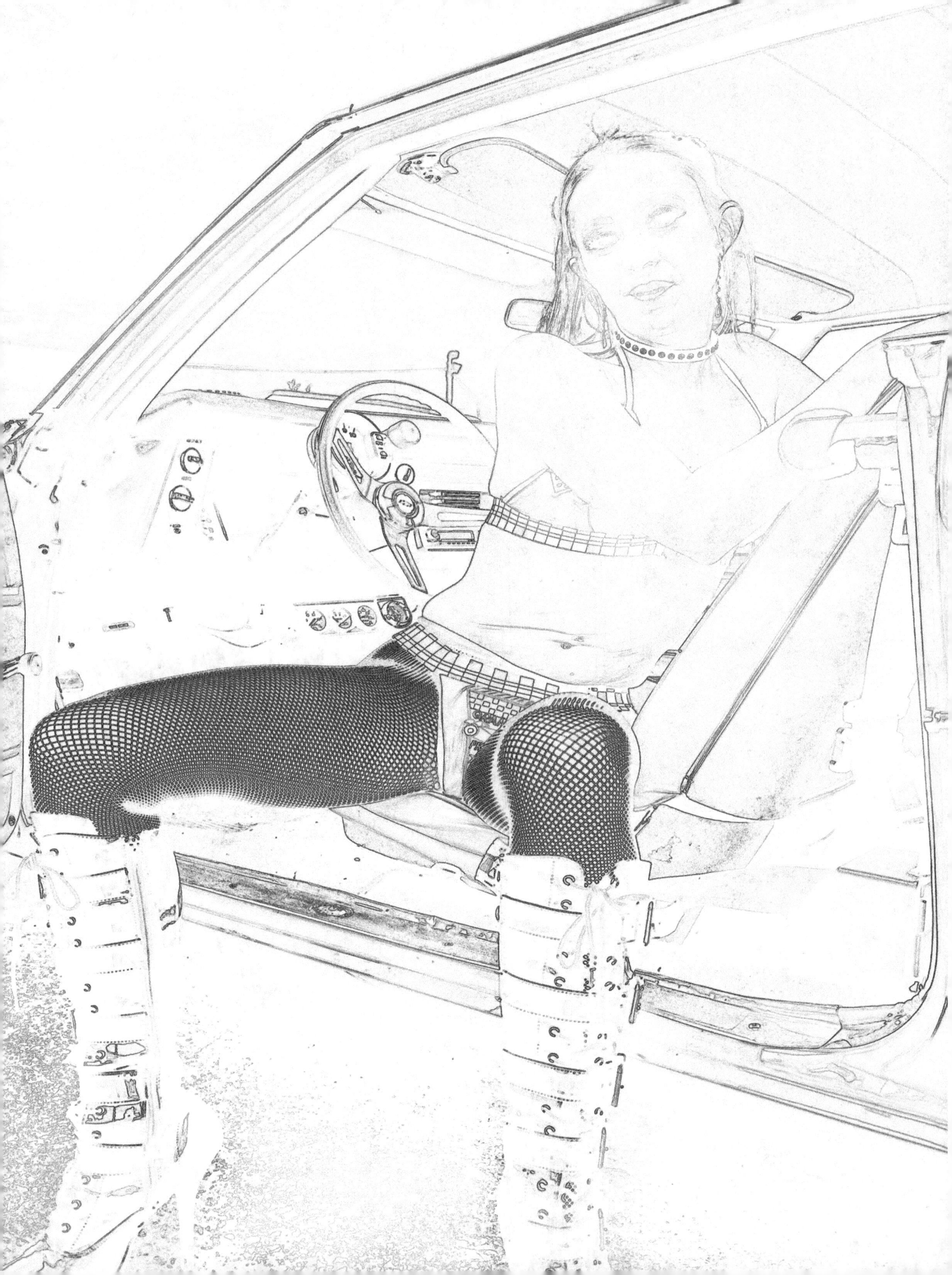

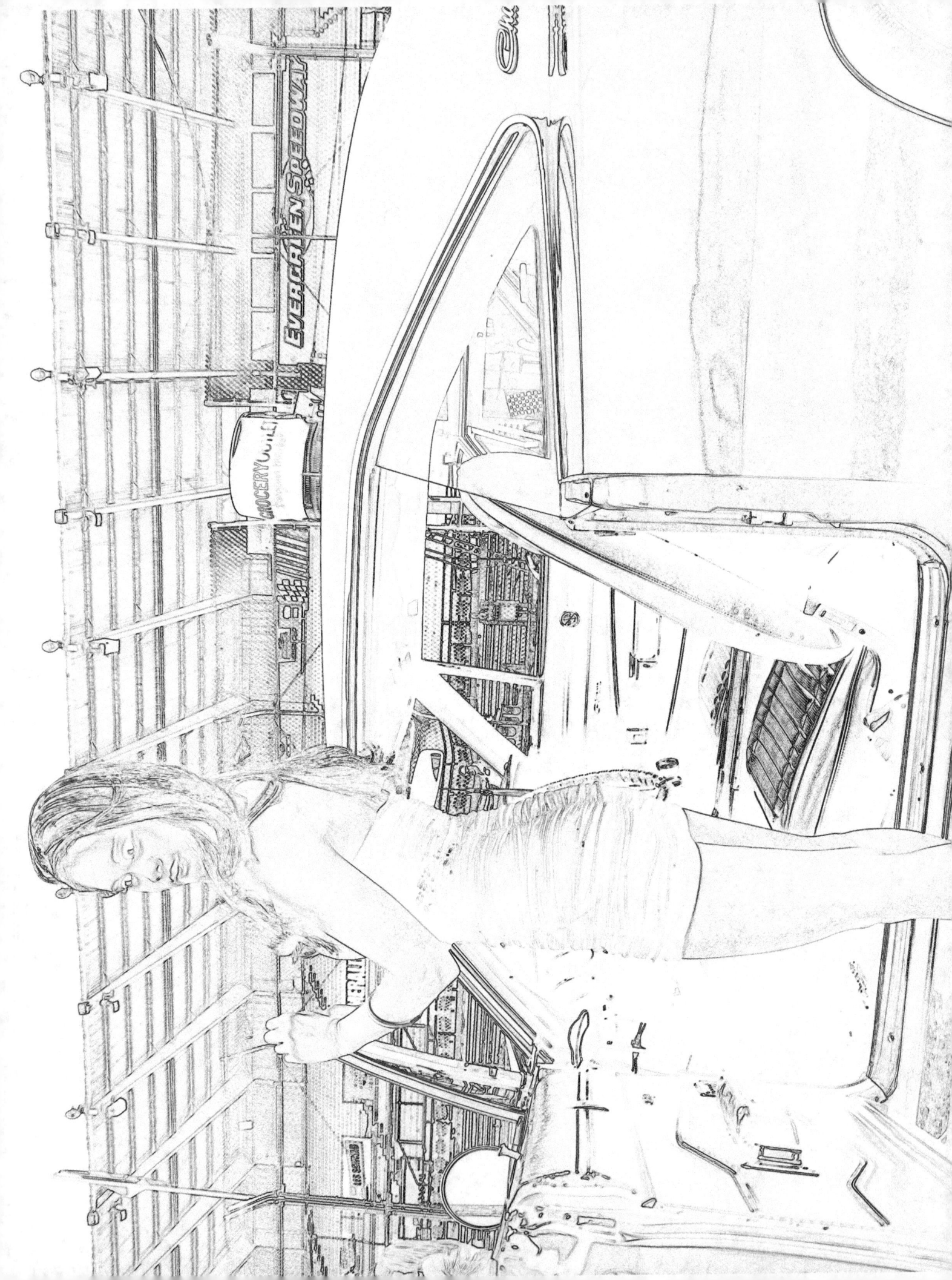

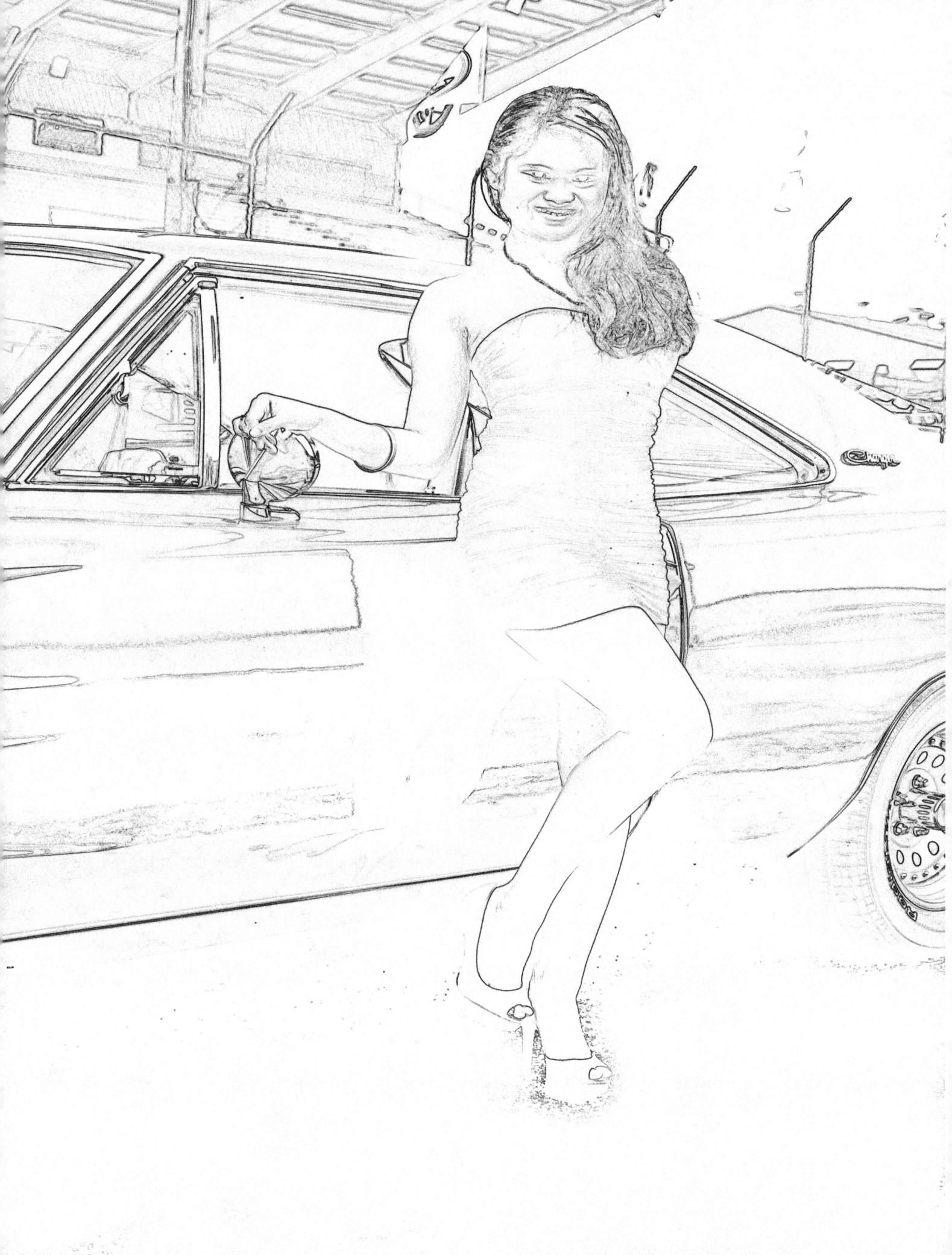

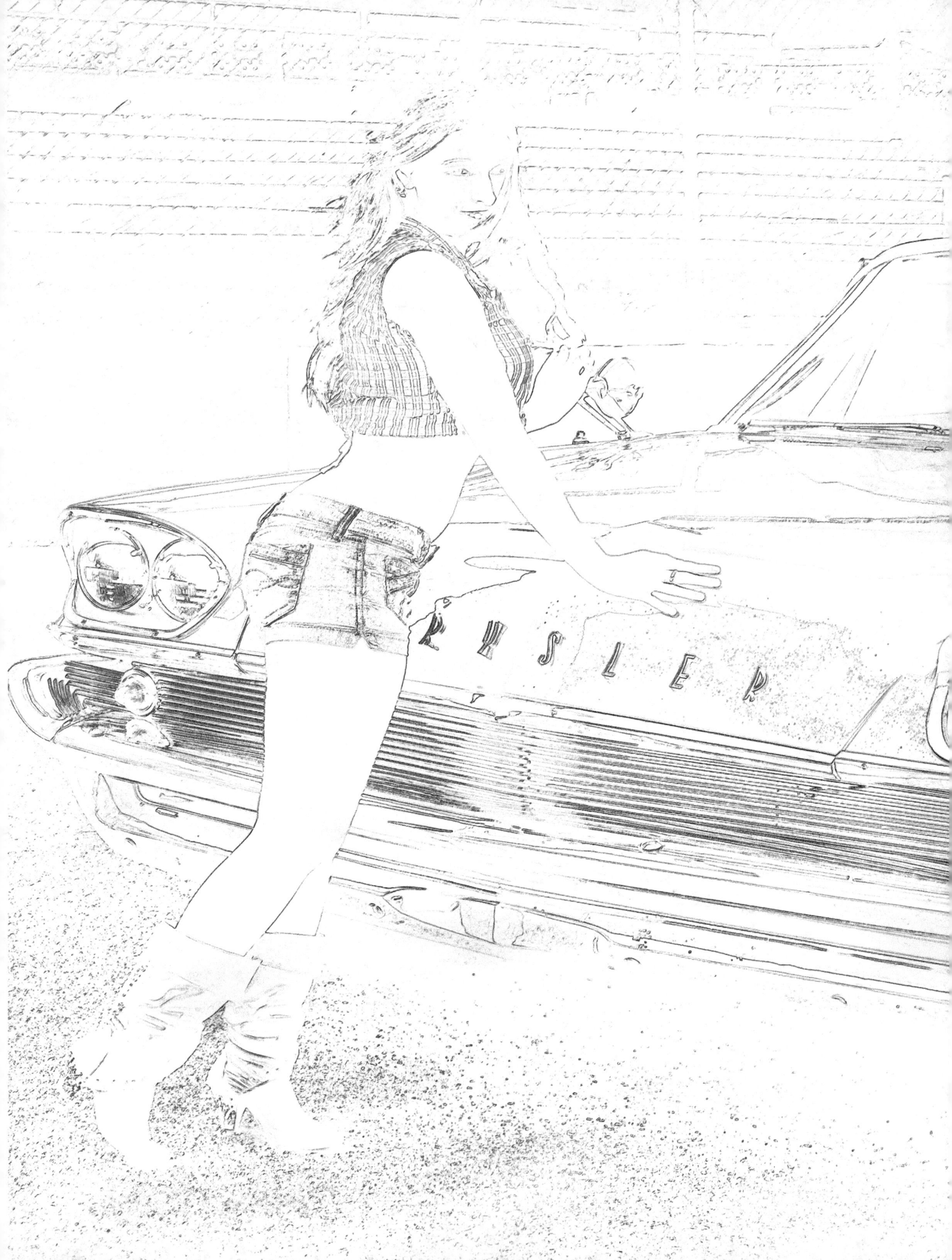

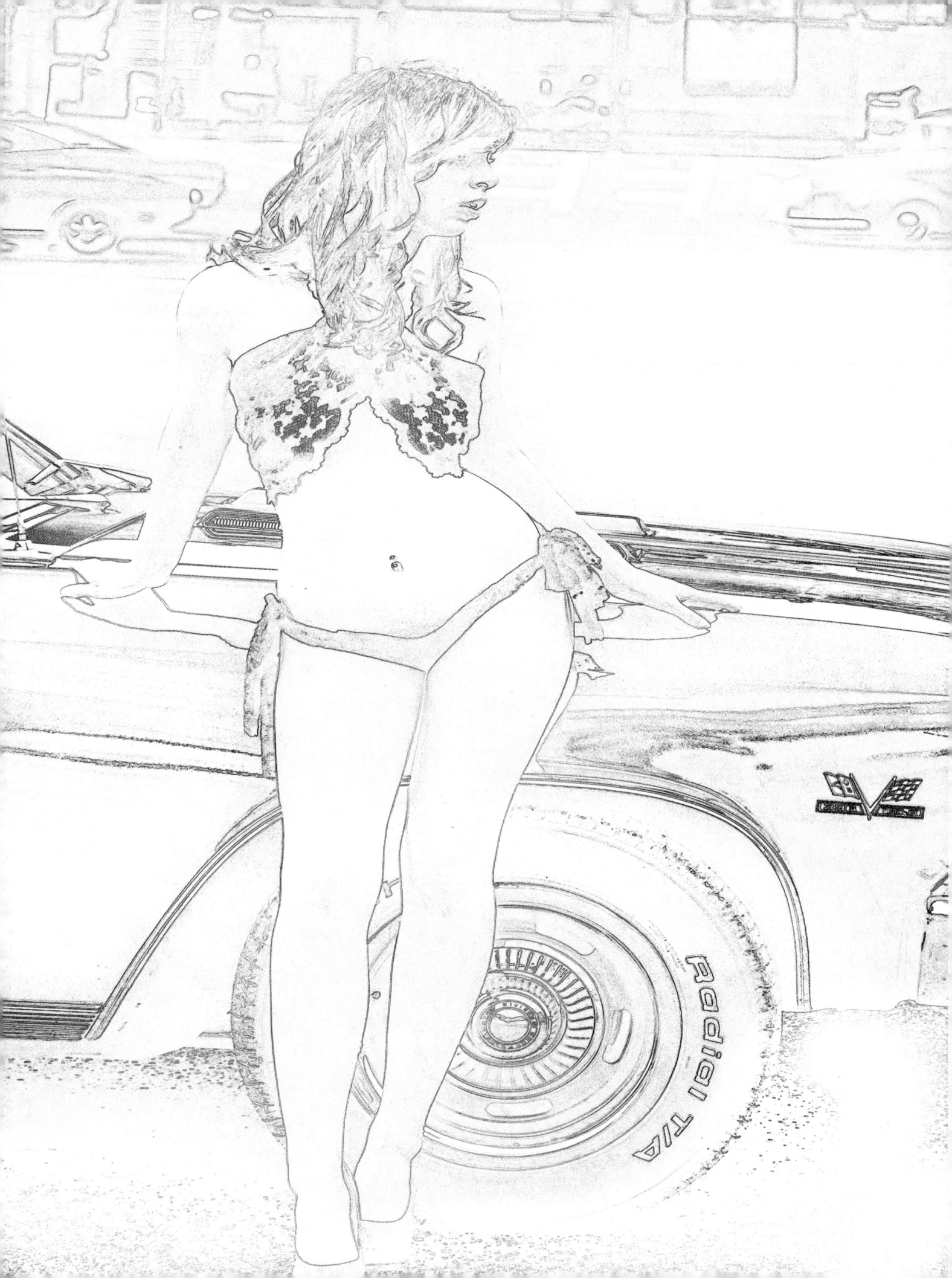

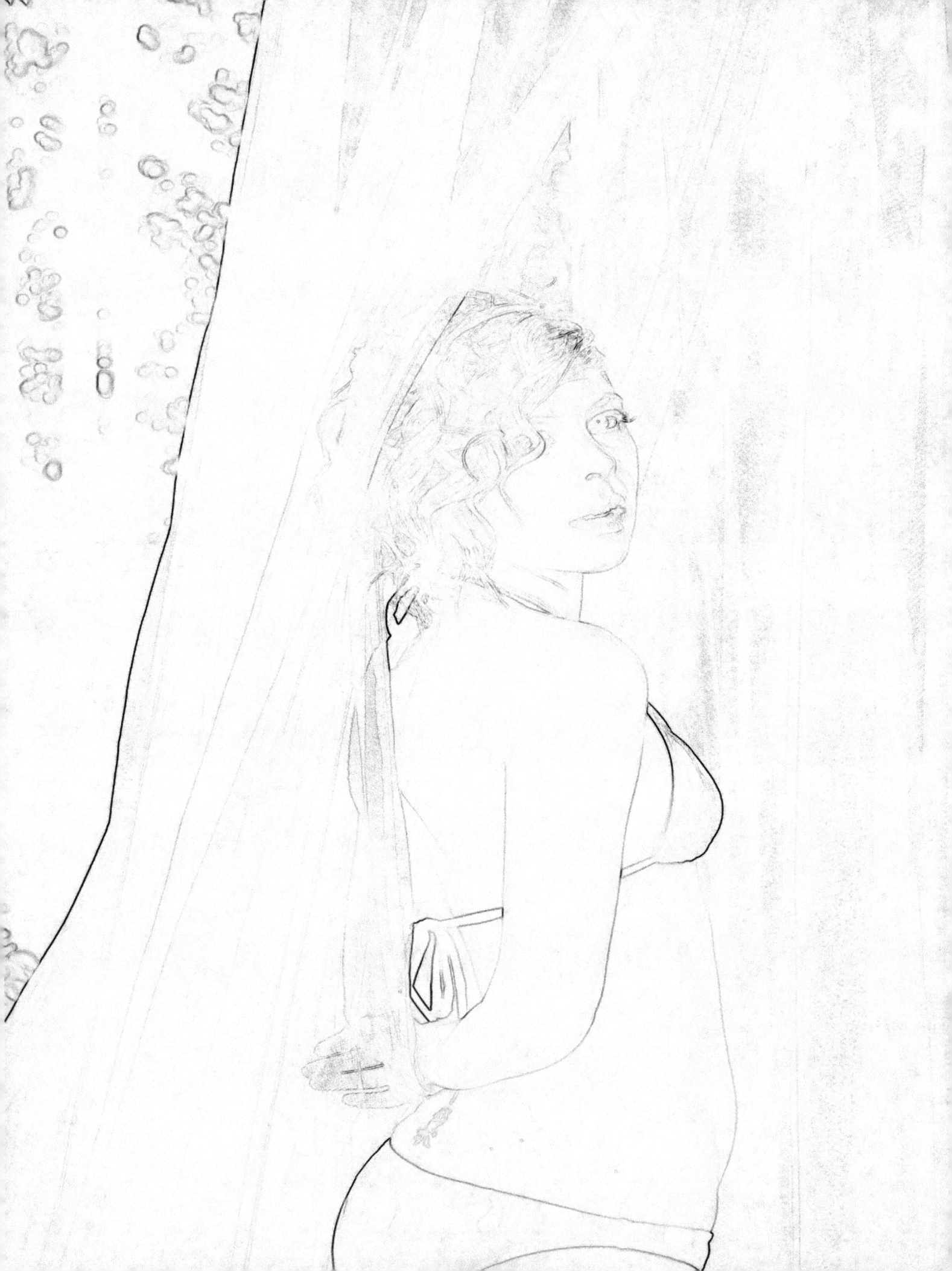

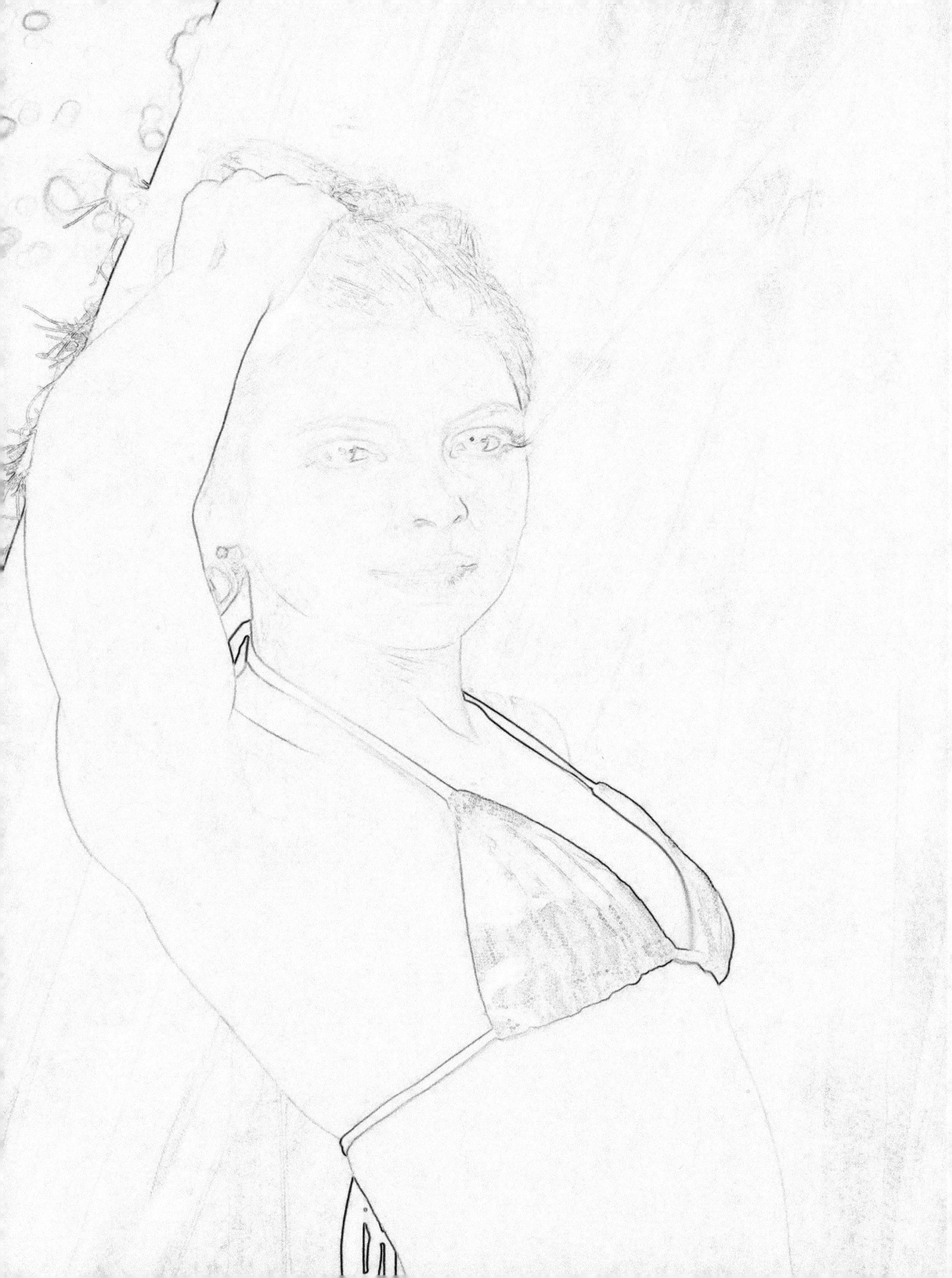

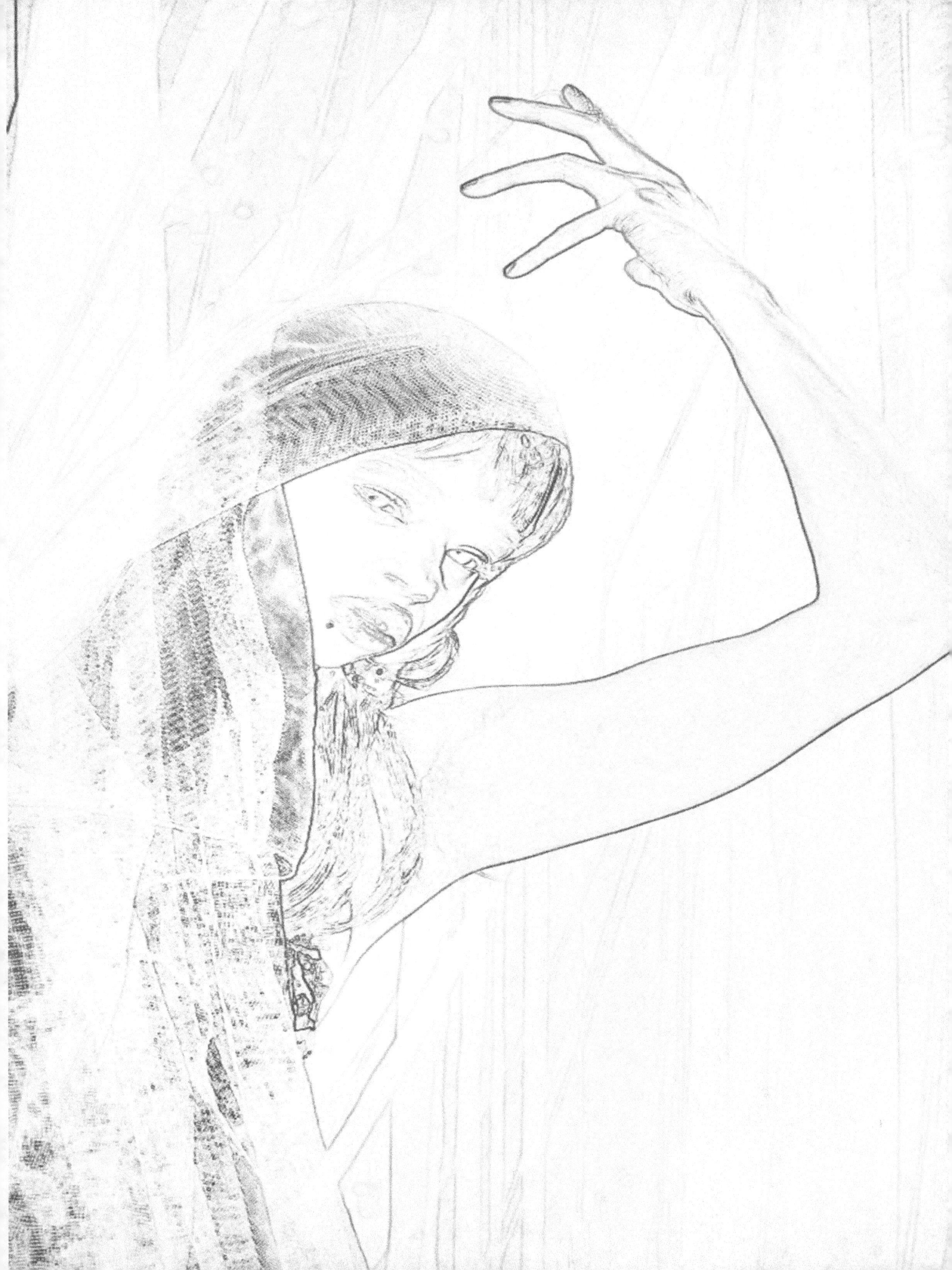

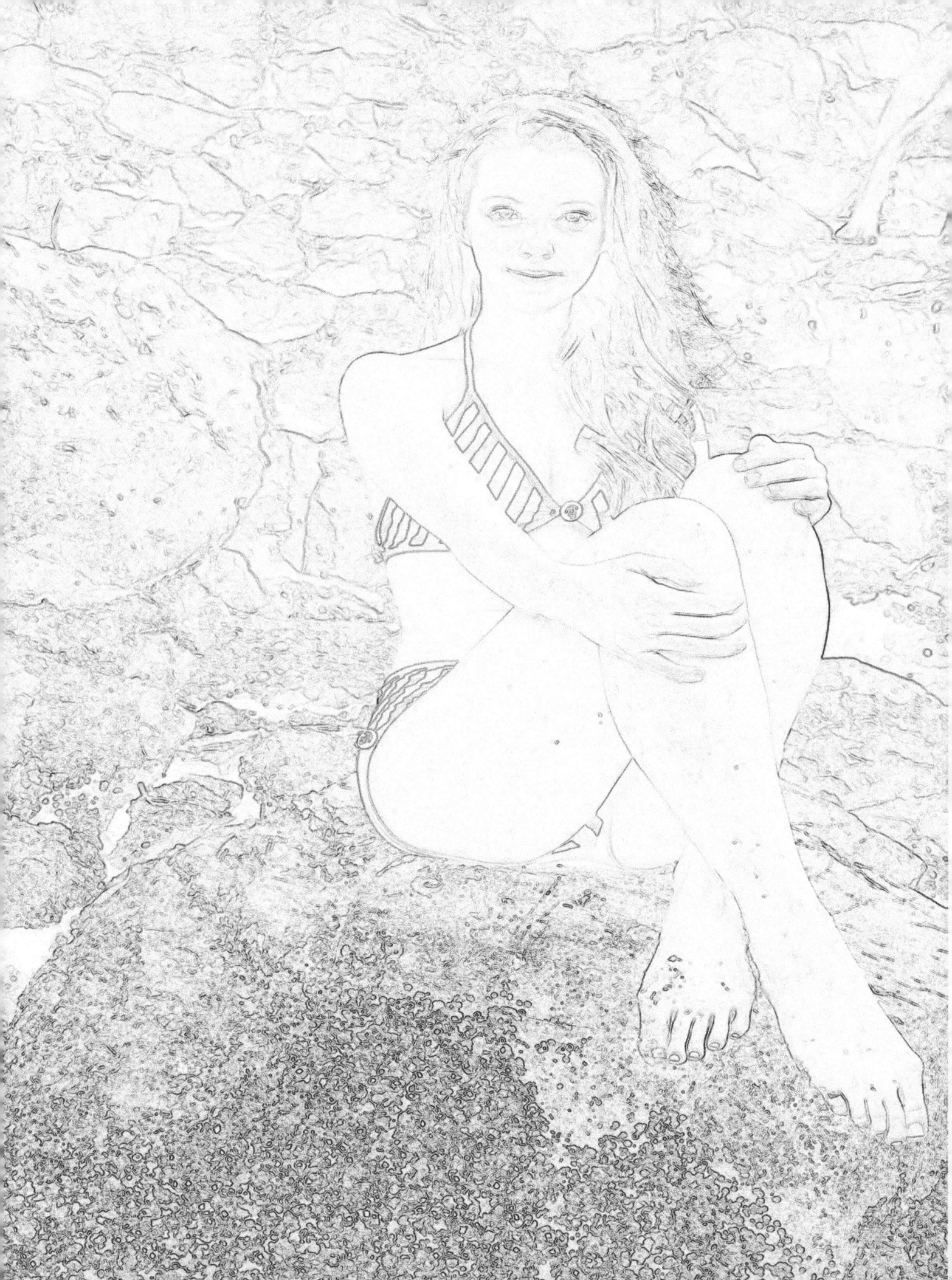

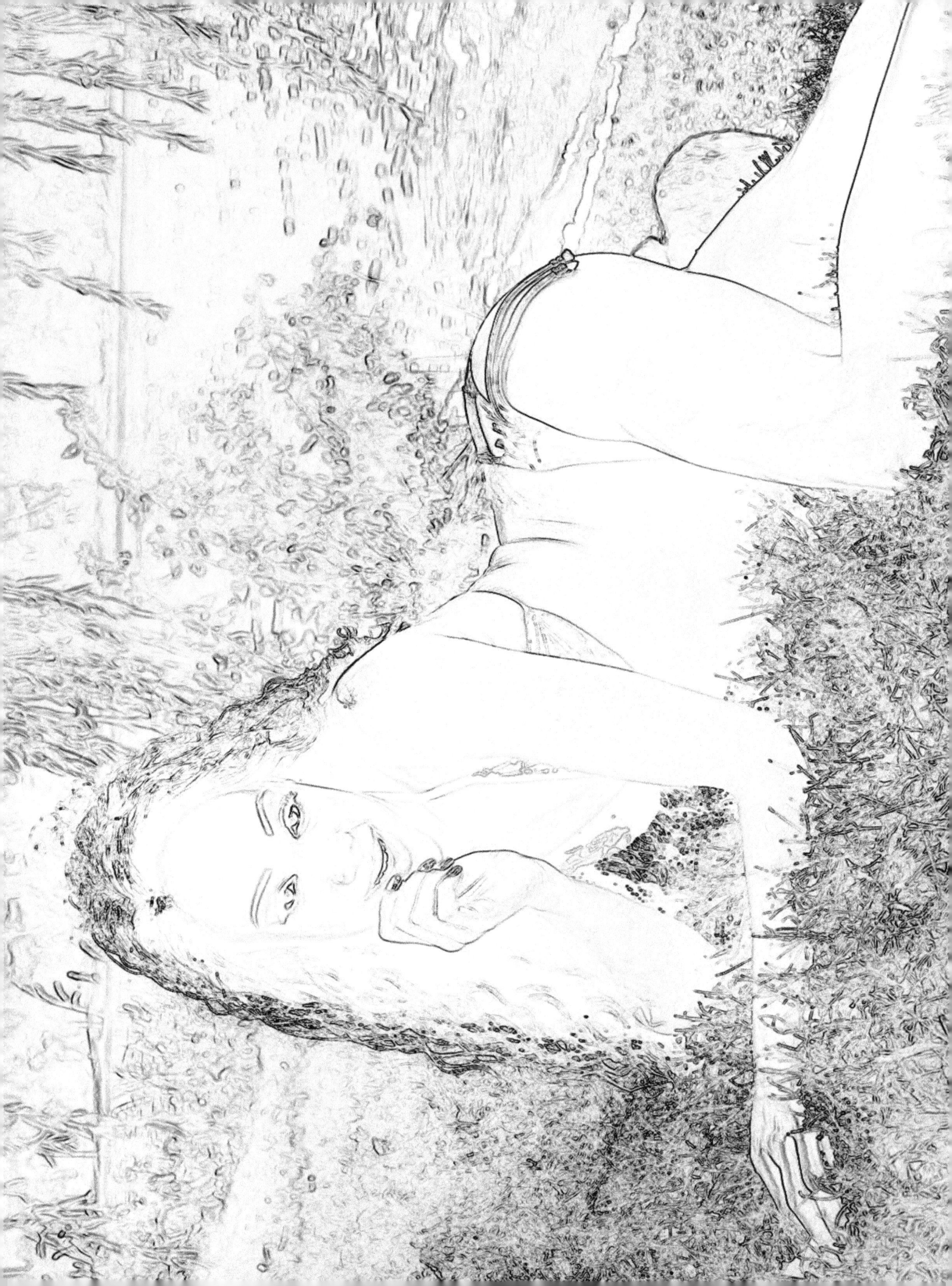

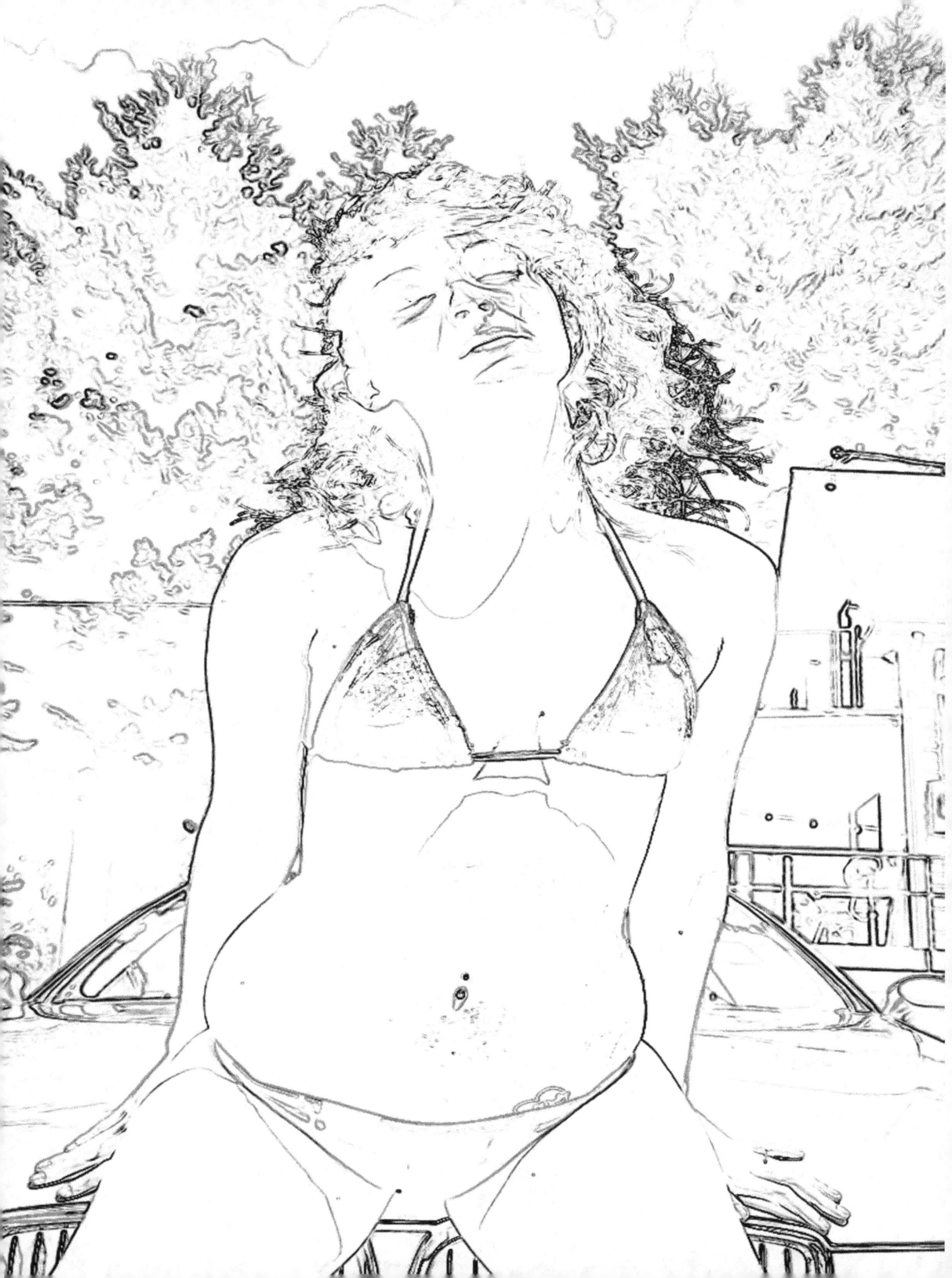

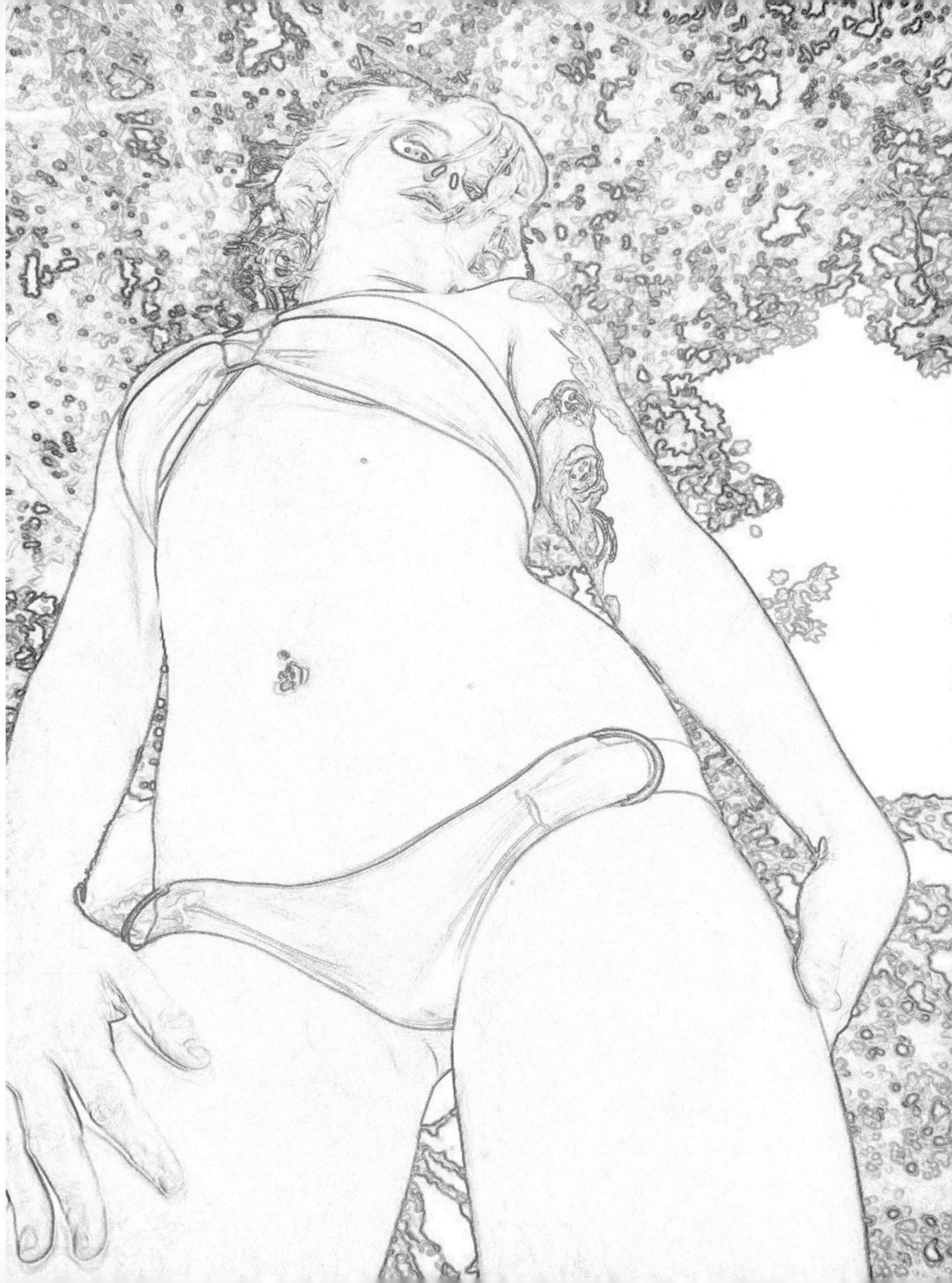

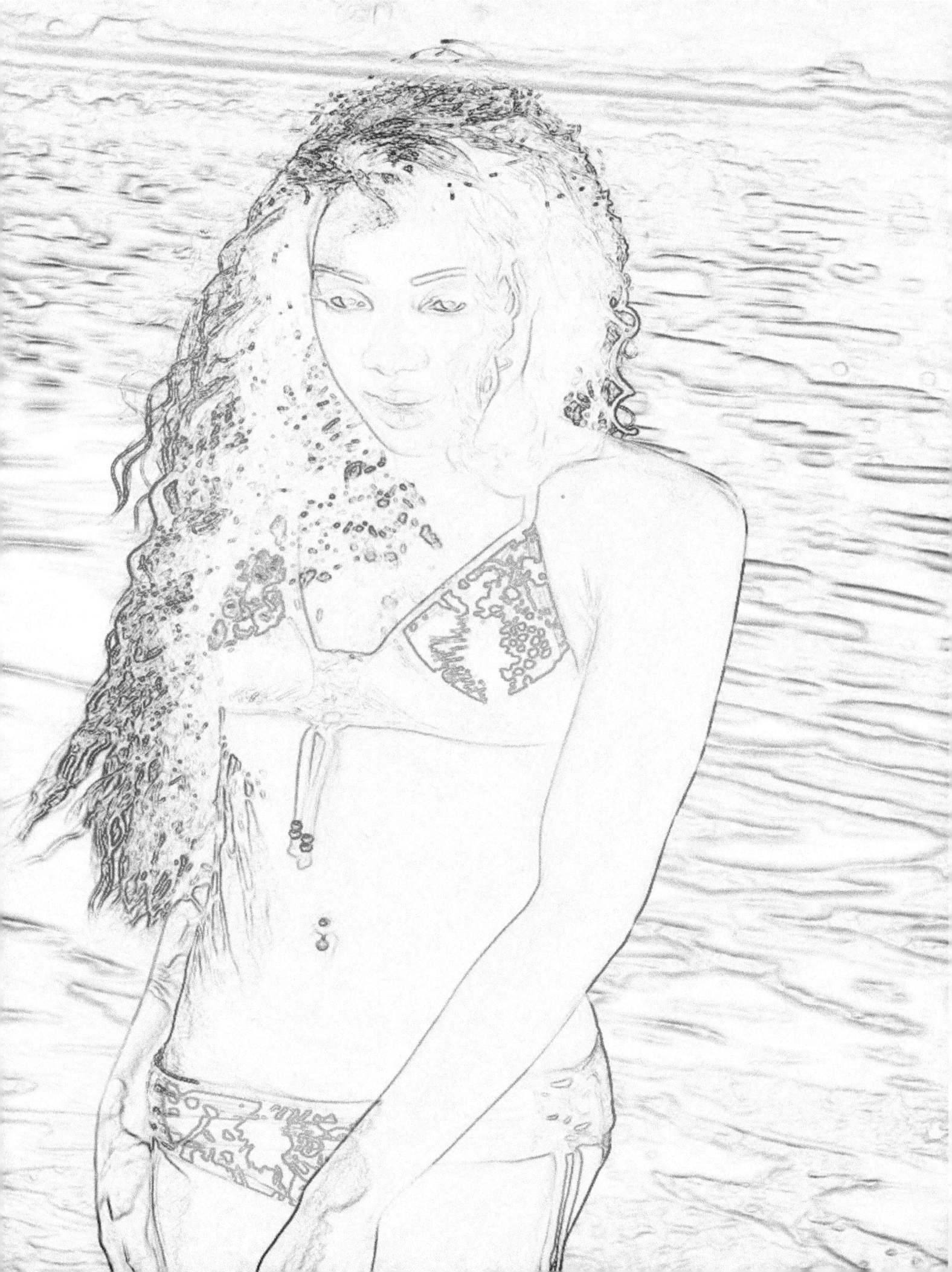

www.ingramcontent.com/pod-product-compliance
Lightning Source LLC
Chambersburg PA
CBHW081147170526
45158CB00009BA/2759